Totally Wired ABC's

Brian Murphy

Totally Wired ABC's

Brian Murphy

FEATHERWING PRESS

BOOKS TO ENLIGHTEN AND INSPIRE TAKE YOUR LIFE TO NEW HEIGHTS

Totally Wired ABC's, by Brian Murphy

Copyright ©2016 by Brian Murphy.

All rights reserved.

No part of this book may be reproduced or transmitted in any form without written permission from the author or his authorized representatives except in the context of reviews. For information, please write: murphcares@gmail.com

Made available by Featherwing Press. Boston, MA. USA

www.murphywired.com

ISBN-13: 978-1533017291

ISBN 10: 1533017298

Totally Wired Sculpture
by Brian Murphy

A self taught artist I started Totally Wired Sculpture in 2002 in addition to my work as a child therapist. Over the years I have spent more time in the creative process, which seems to be a nice balance to my work with children who have experienced trauma.

My work can be seen as lighthearted line drawings in the medium of steel wire. Often political and humorous themes are incorporated which can challenge or amuse the viewer leaving them uplifted. The goal of each piece is to create kinetic movement from the tension in the wire so that the figures seem to dance or sway on their own and appear enlivened. Mythological themes and tales of transformation dominate, illustrating the power of art to help us change and grow.

A is for Apple

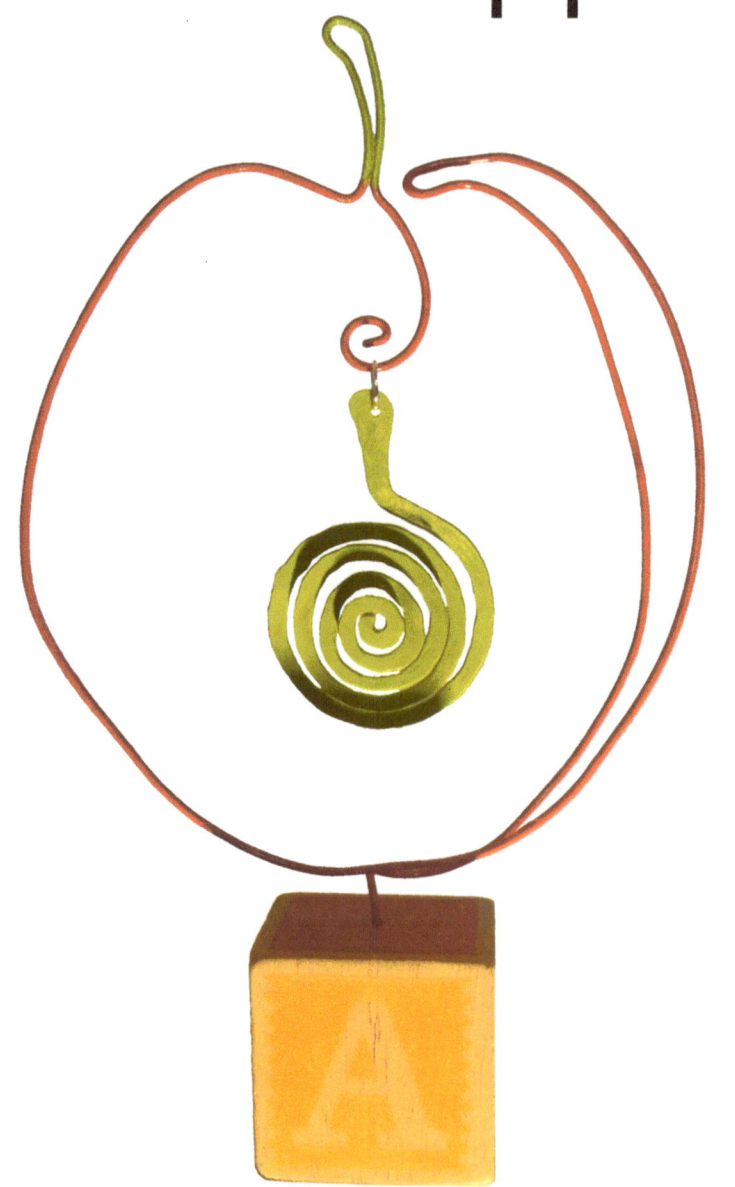

that sometimes goes bad

B is for Baseball

Red Sox Nation is glad

C is for Cat

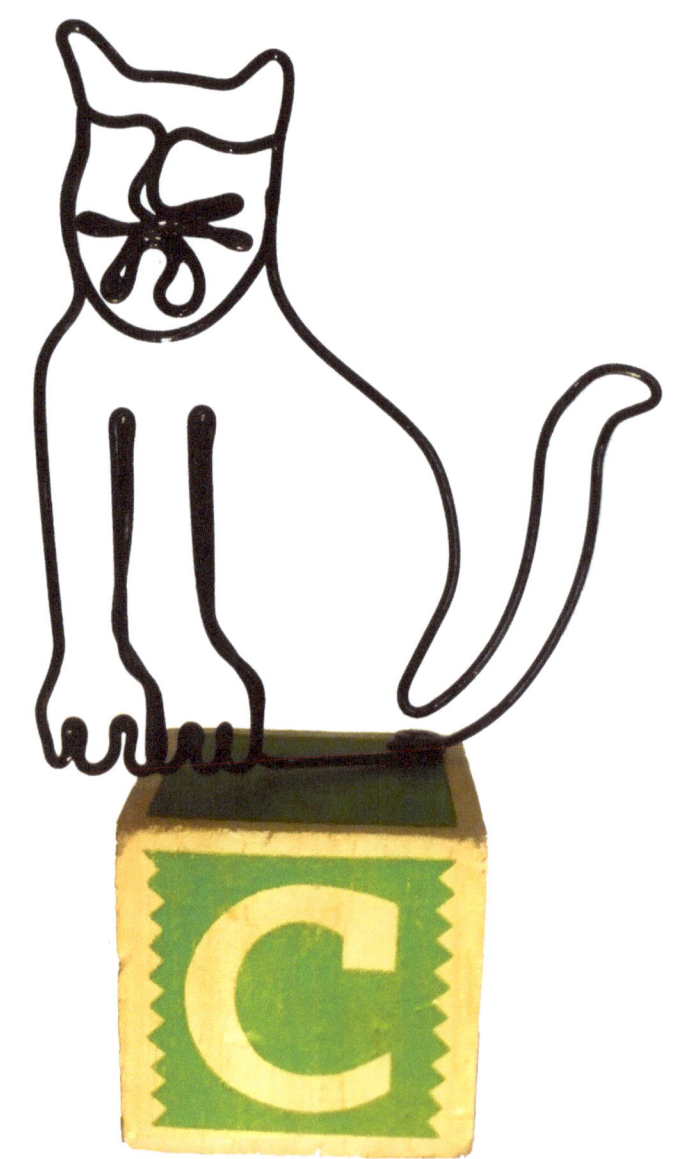

who sleeps on the floor

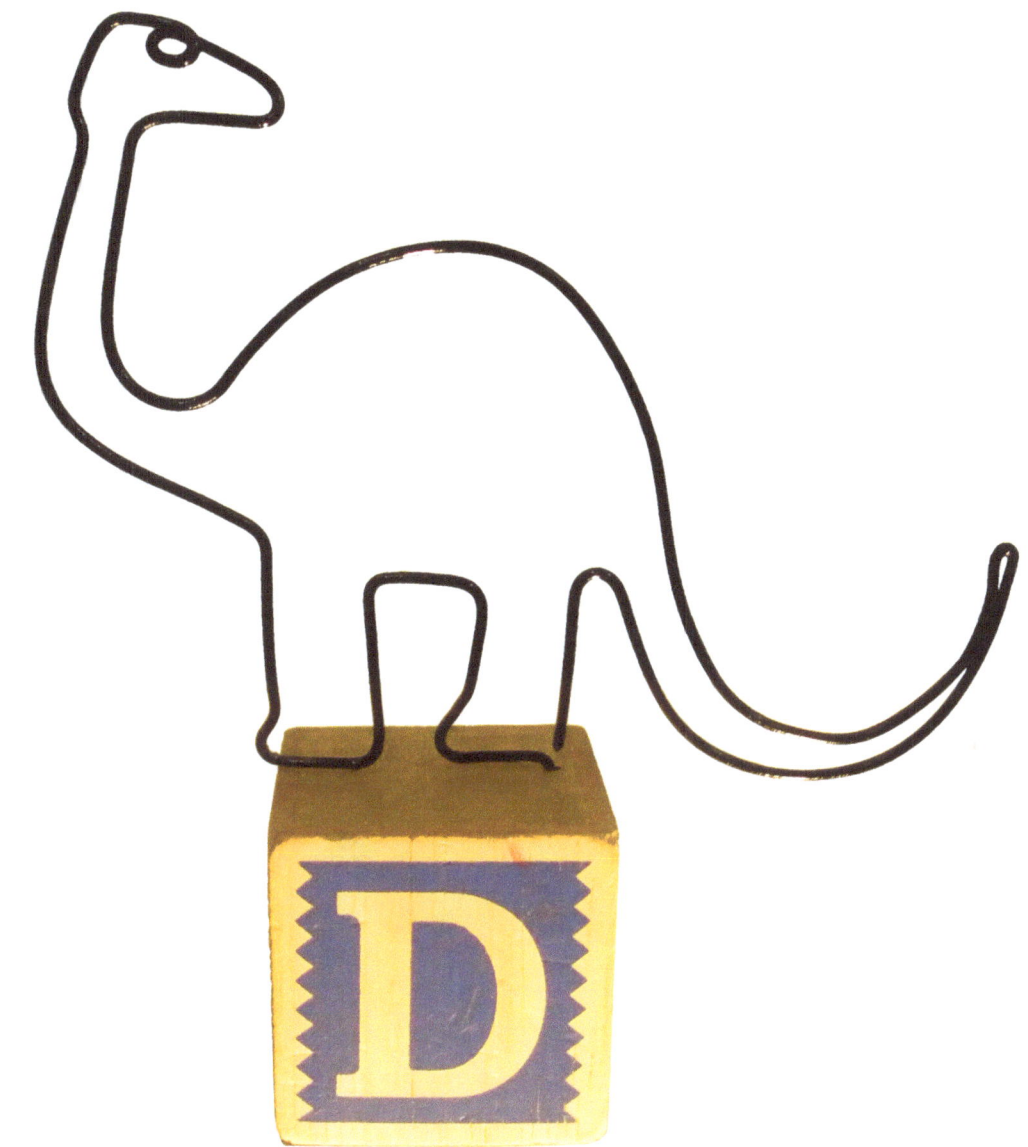

D is for Dino
who now is no more

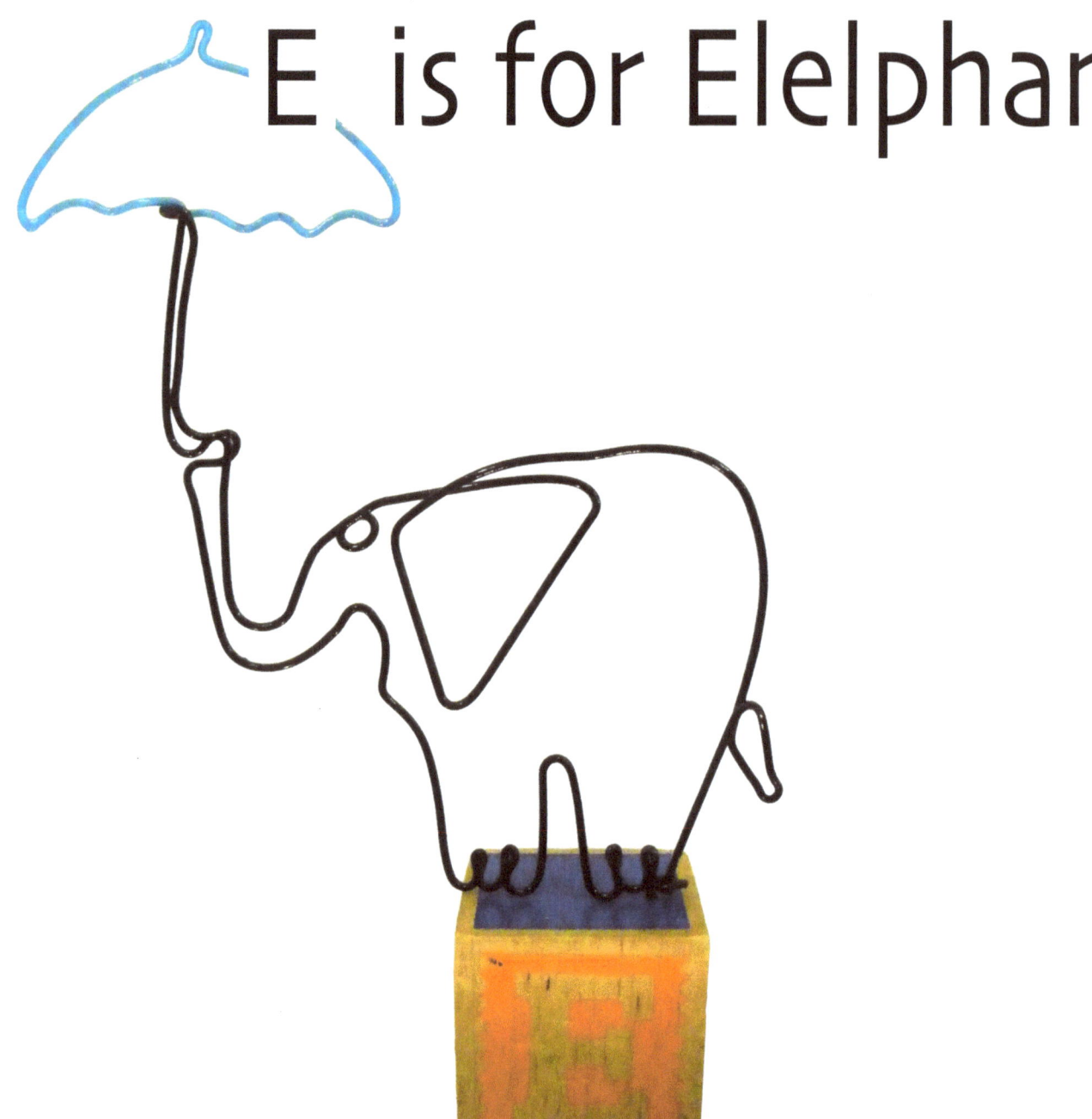

F is for Flamingo

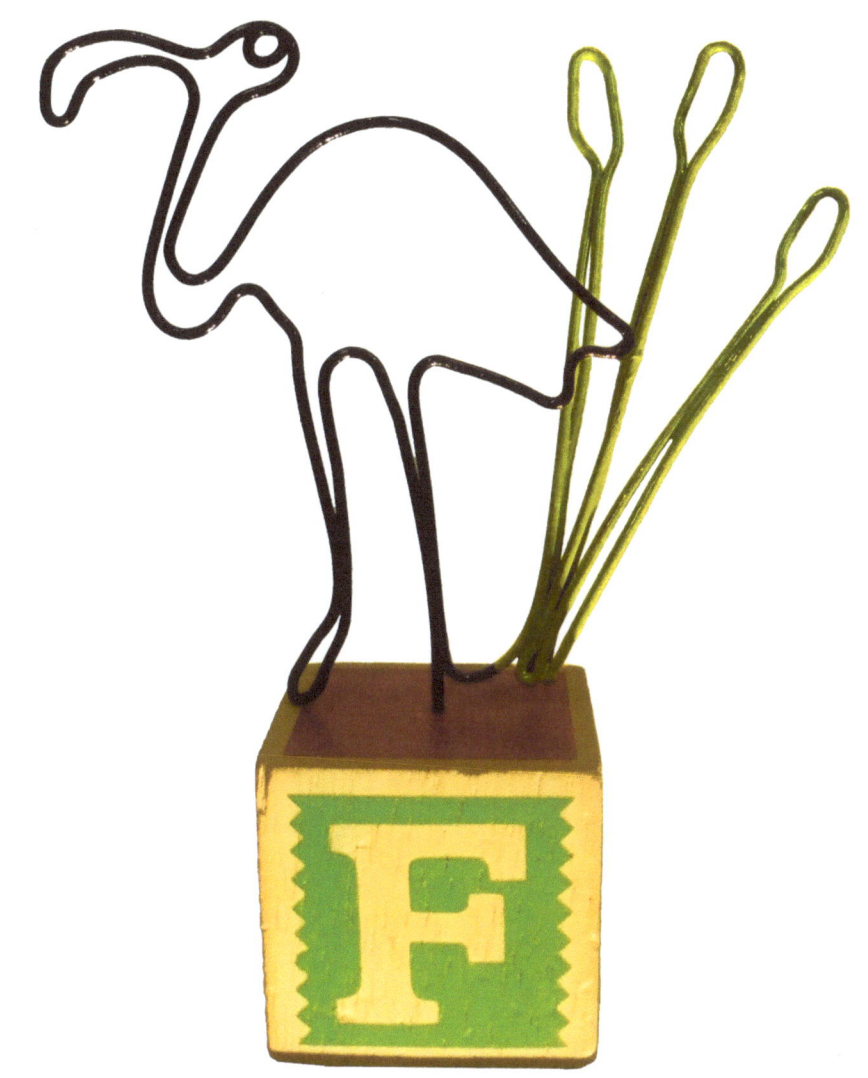

that lives Ever-glade

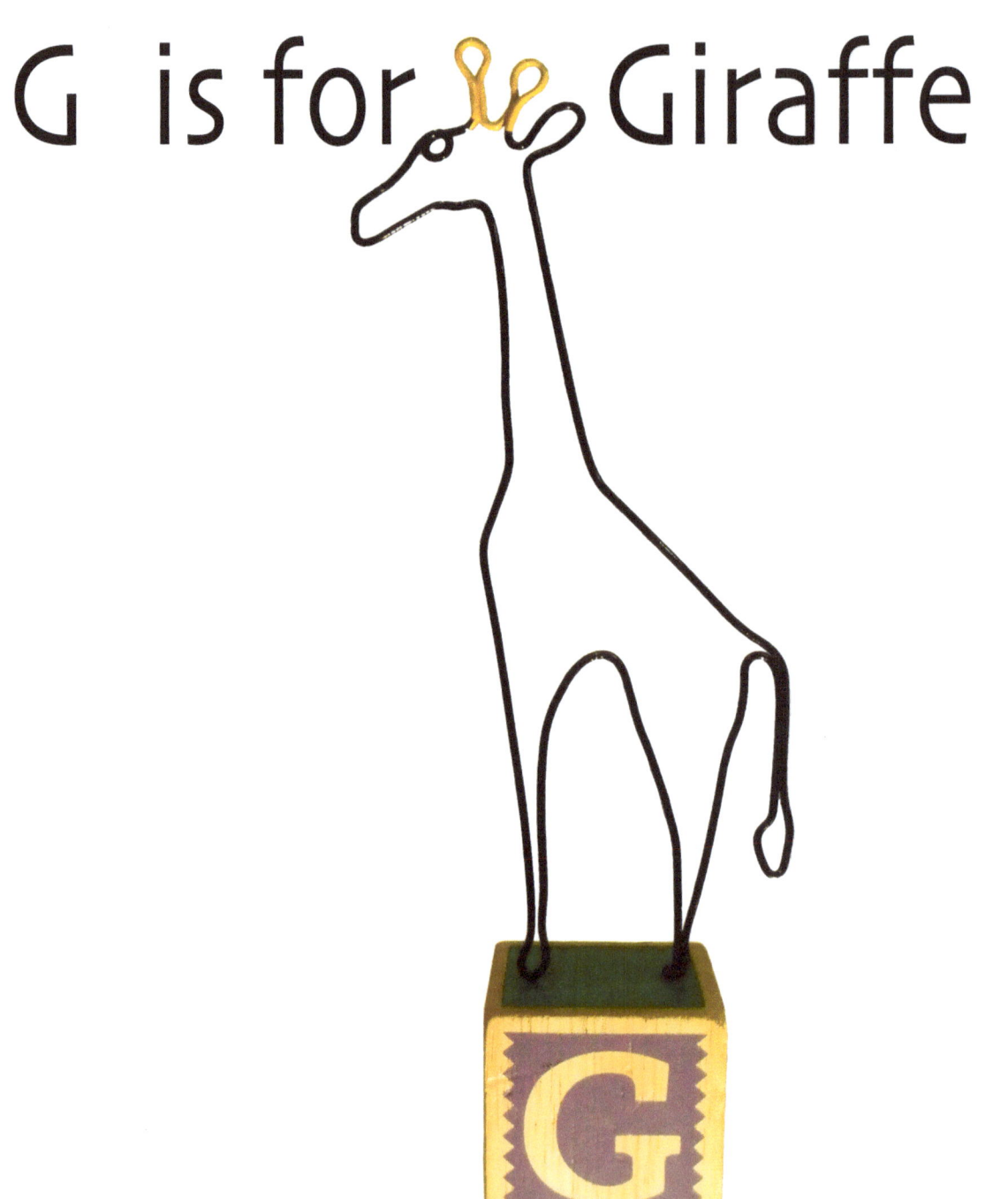

G is for Giraffe
who can see far away

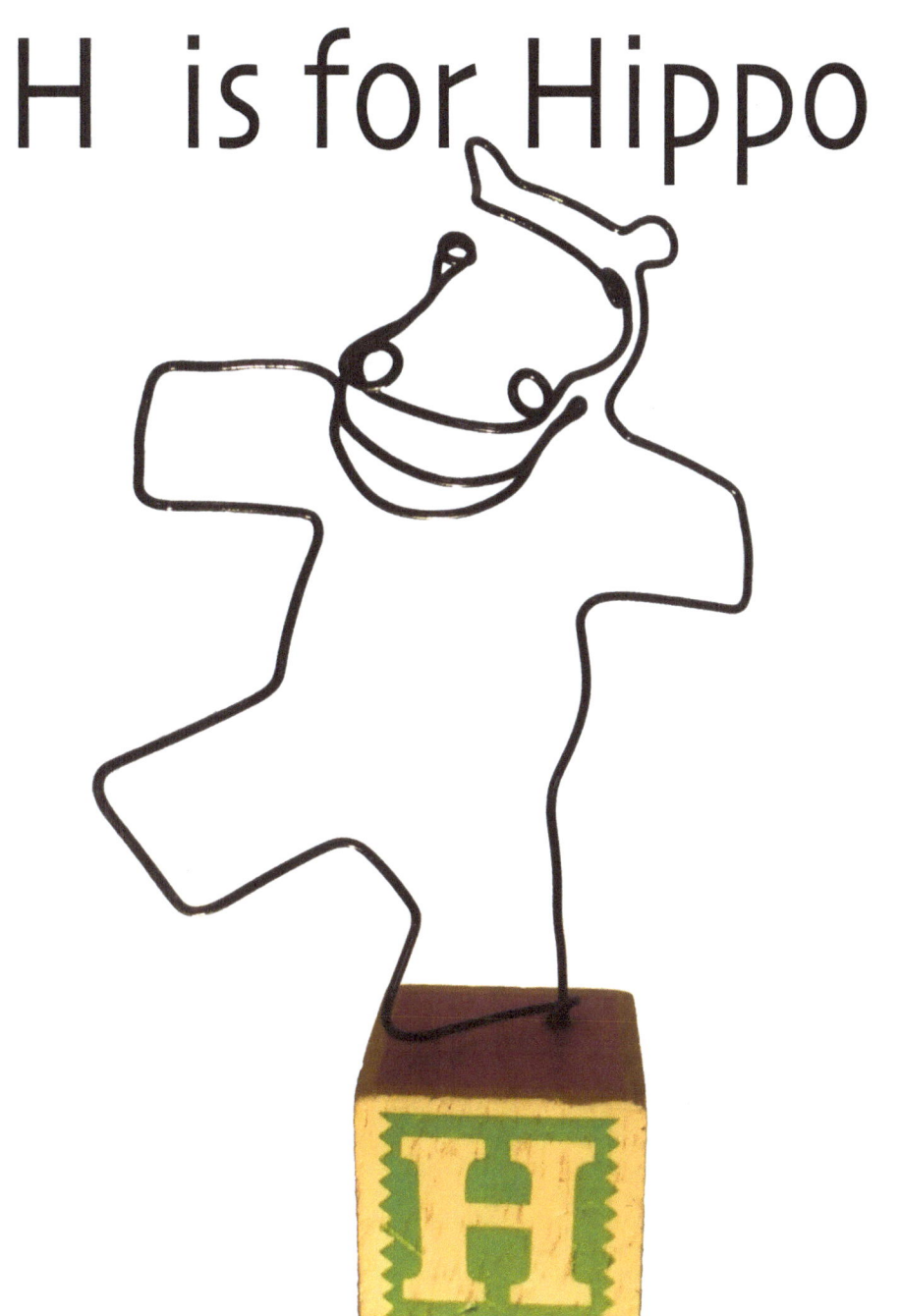

H is for Hippo
that loves to sashay

I is for Ice skater

who glides on the lake

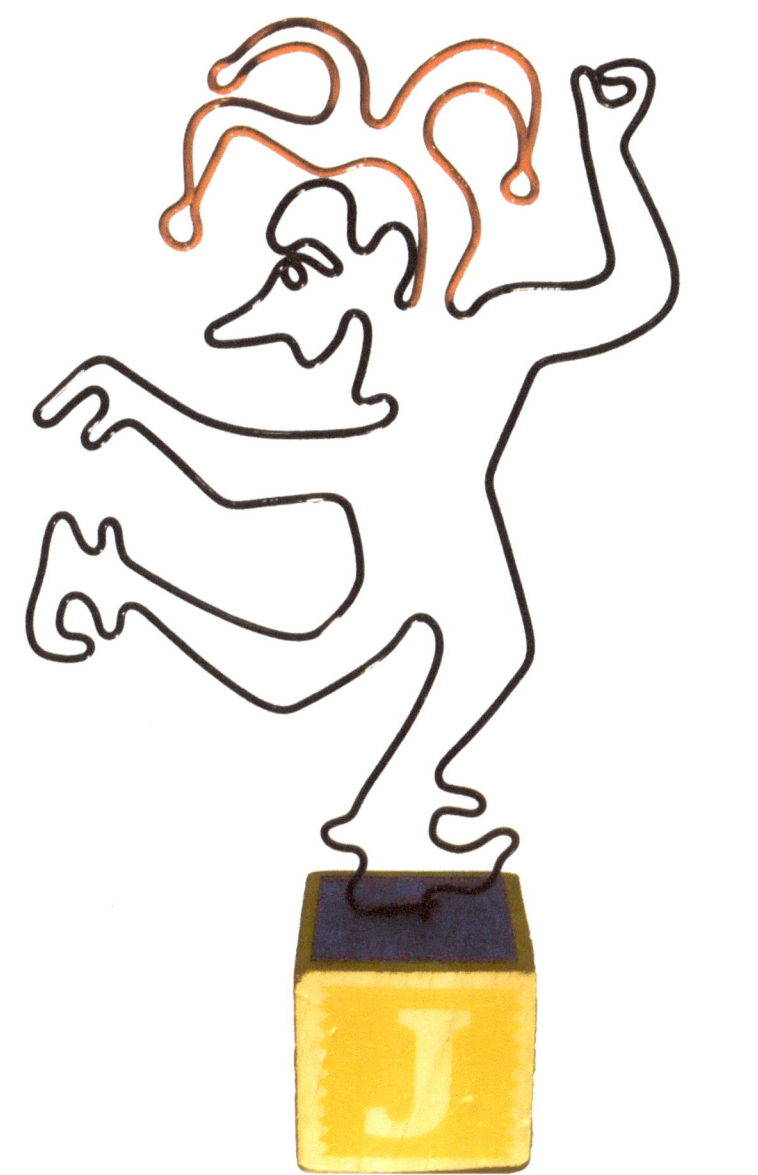

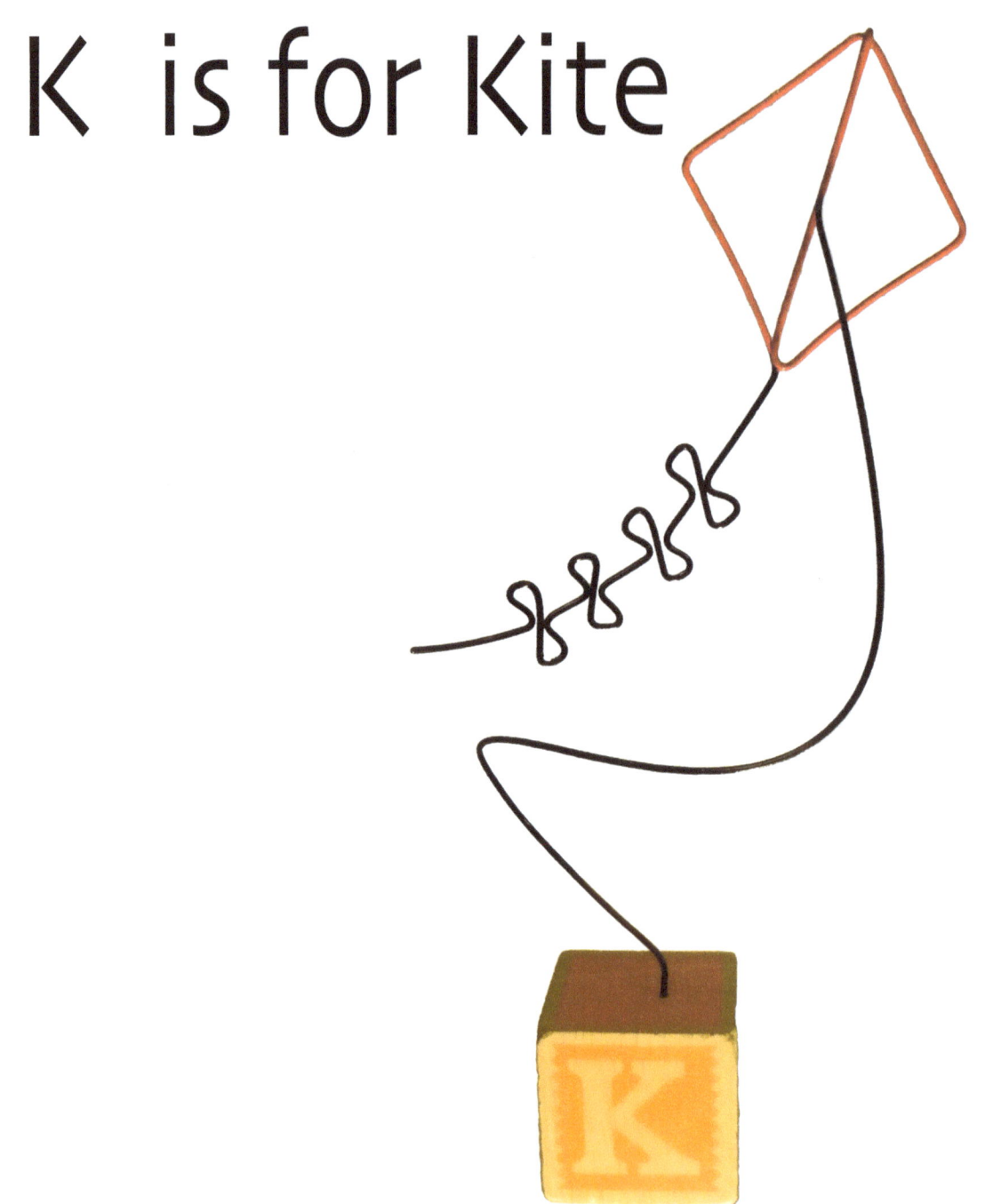

L is for Lion

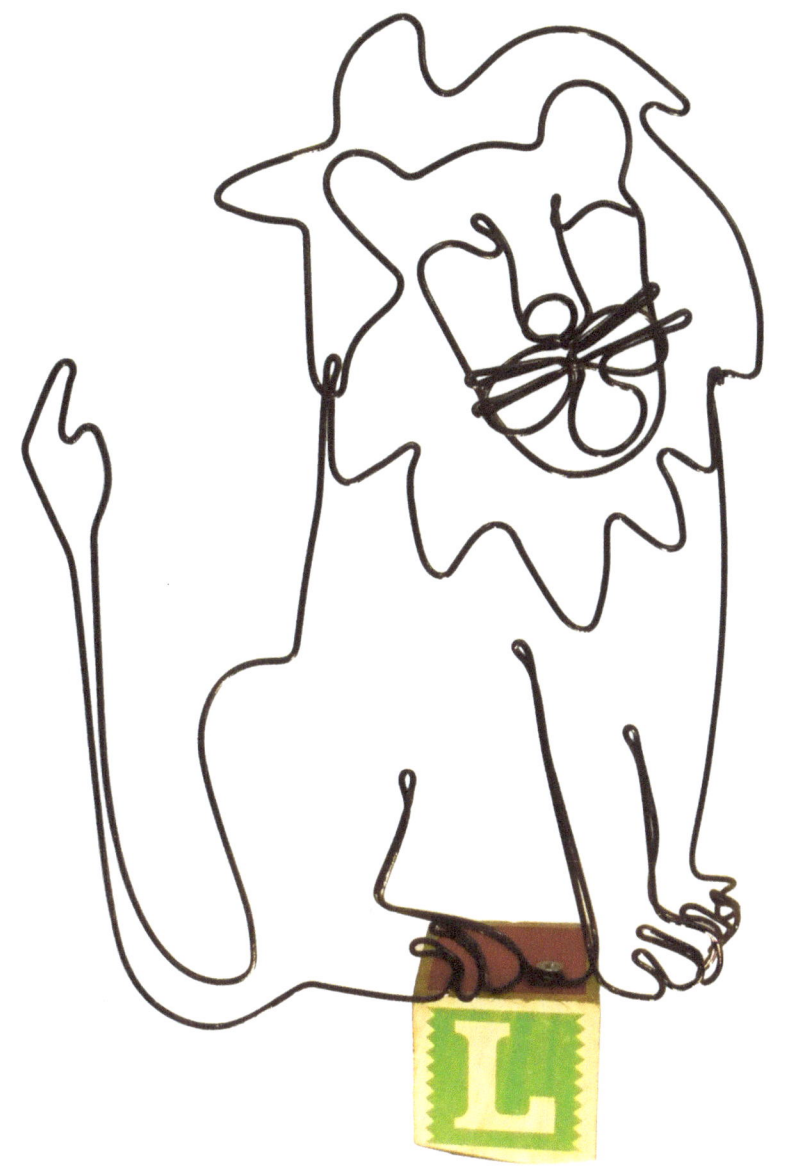

who lives in a lair

M is for Mouse

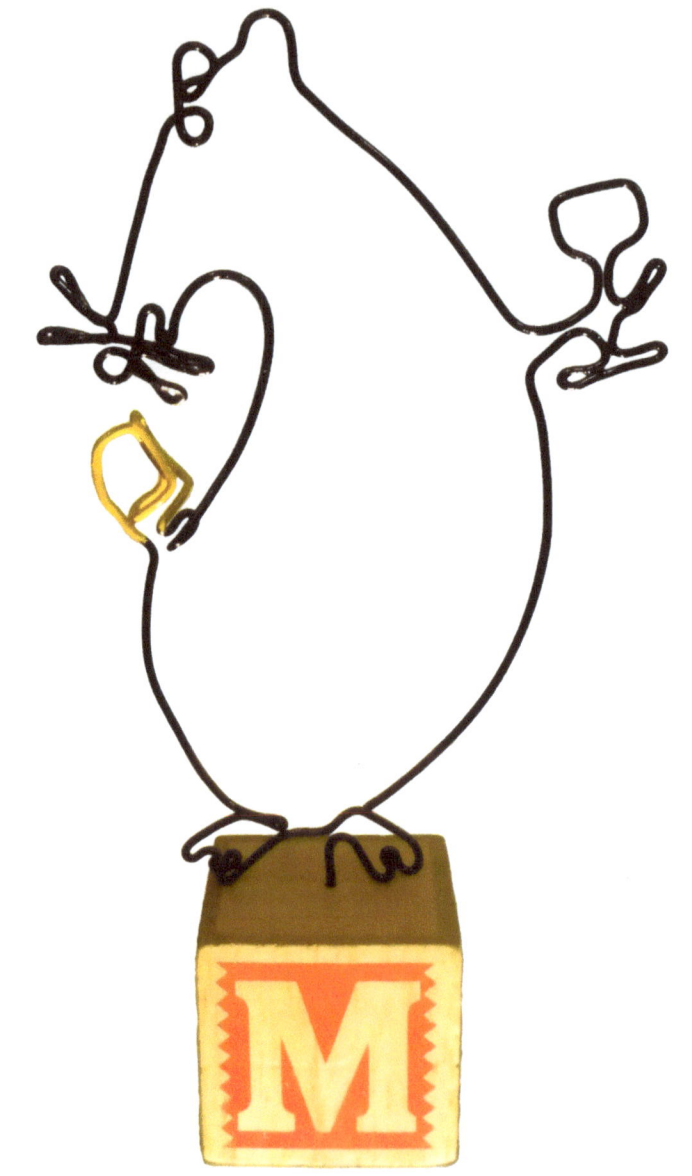

who nibbles his cheese

N is for Newt

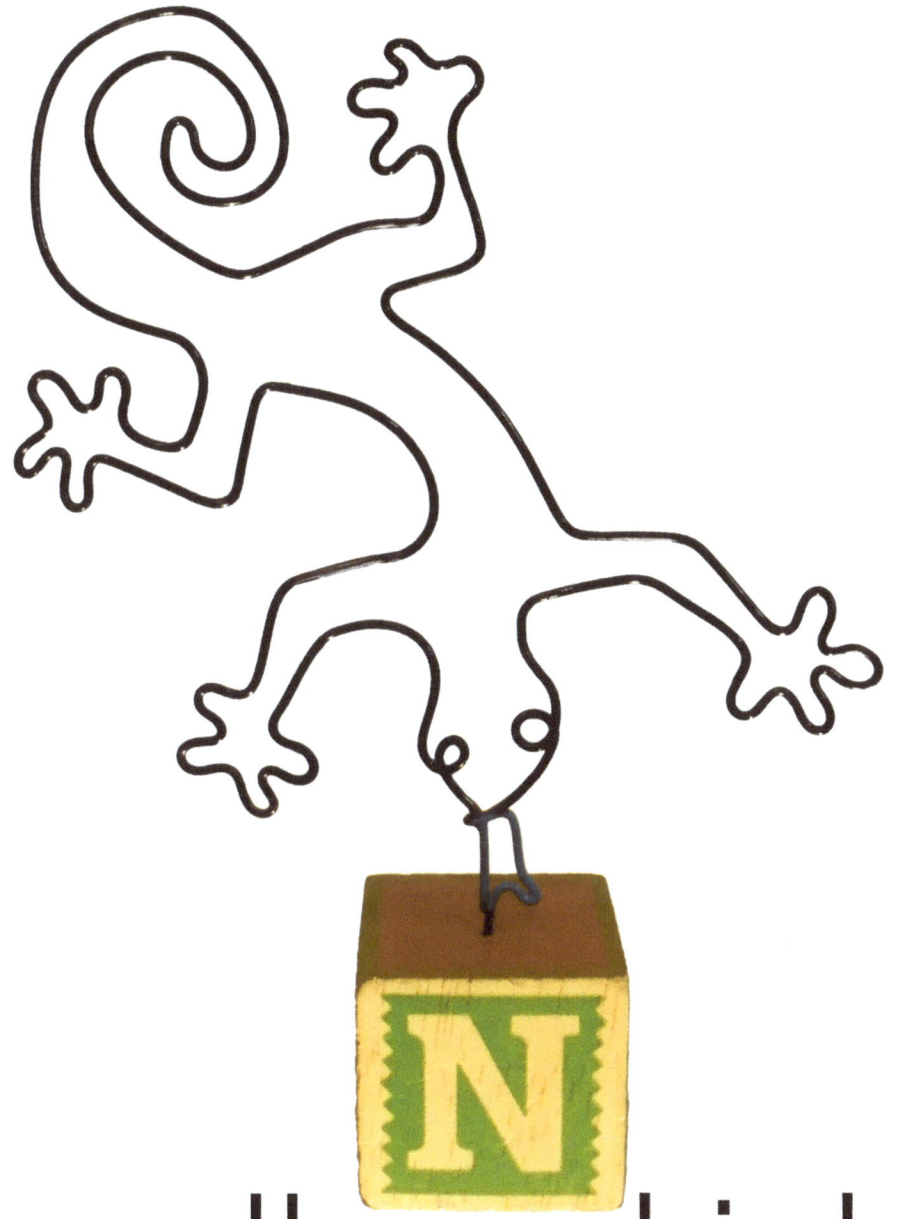

who walks on his knees

O is for Ostrich

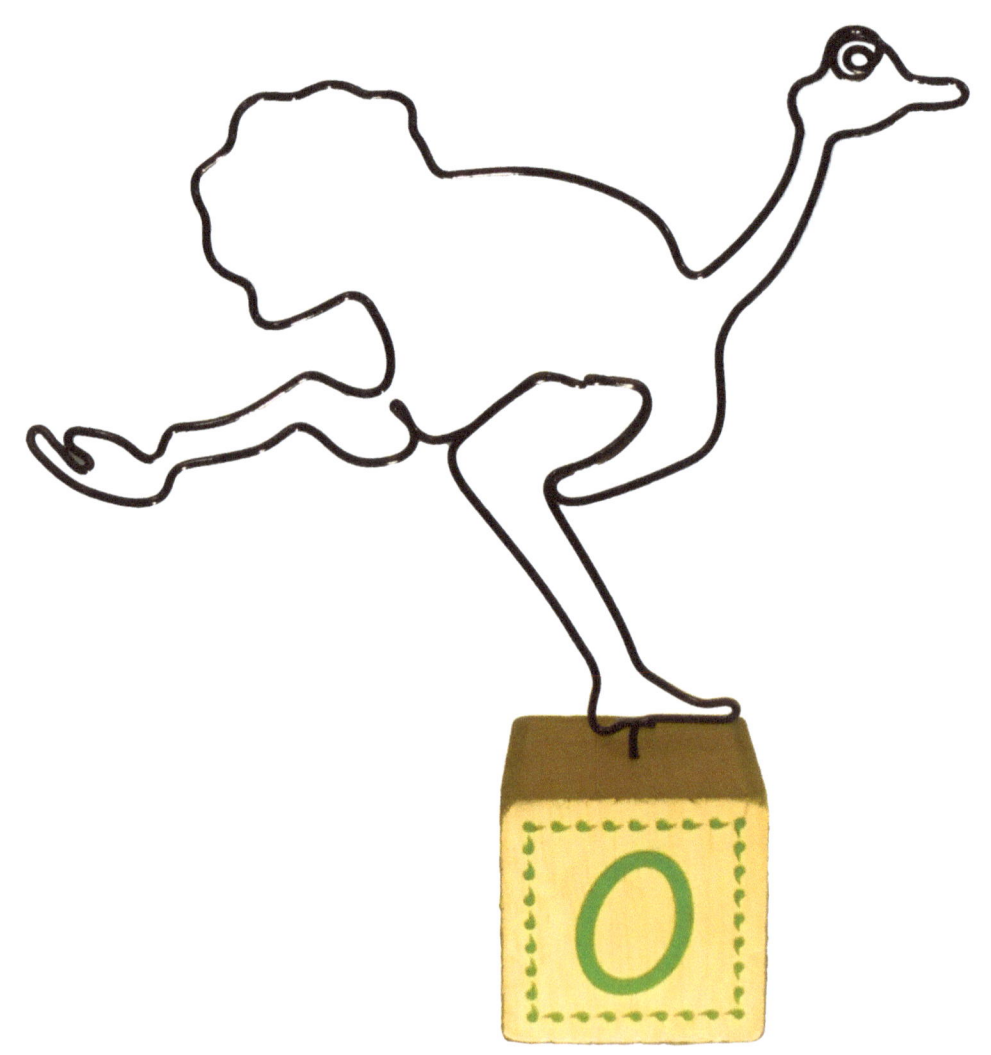

that runs all night long

P is for Piper

who might play you a song

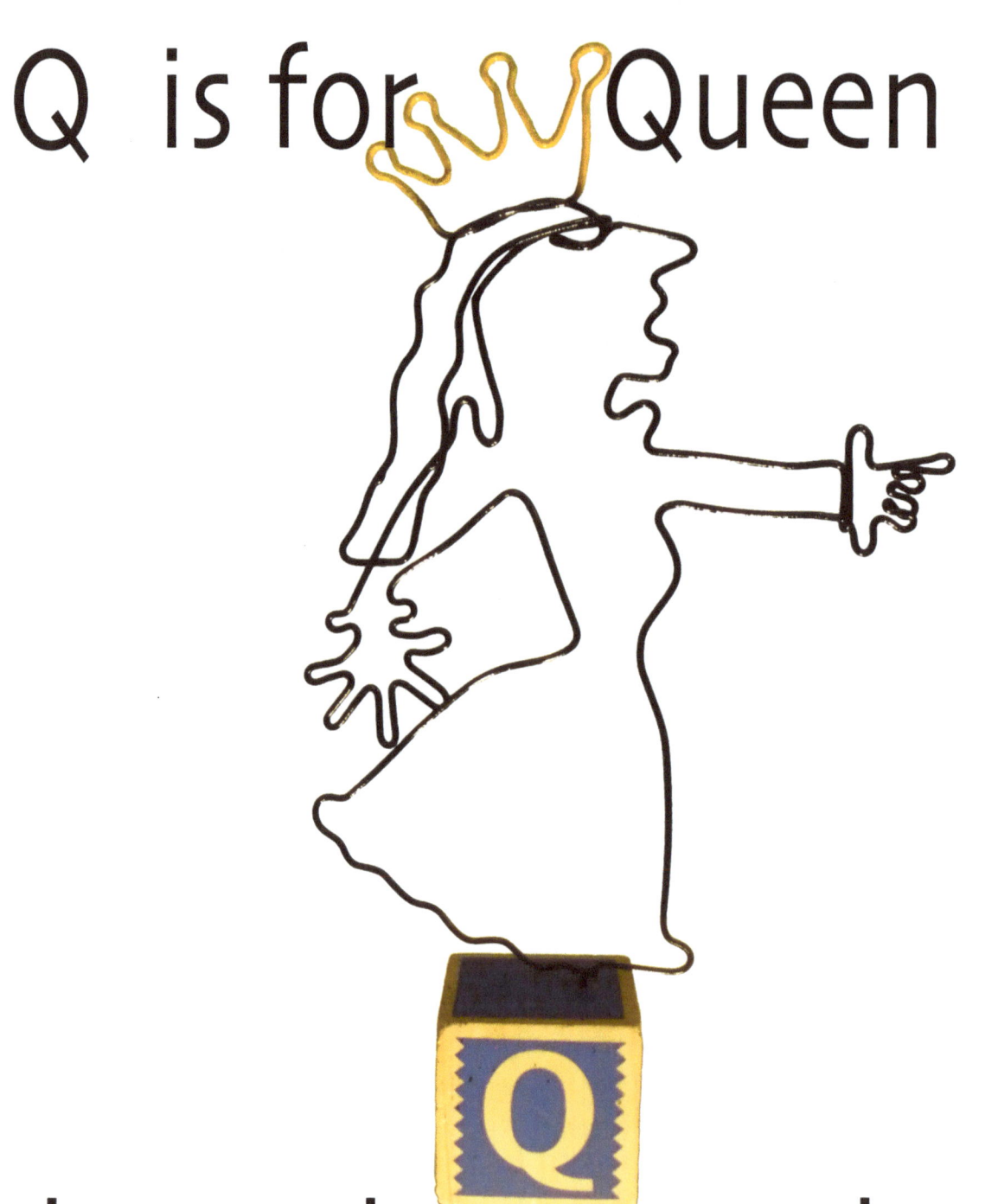

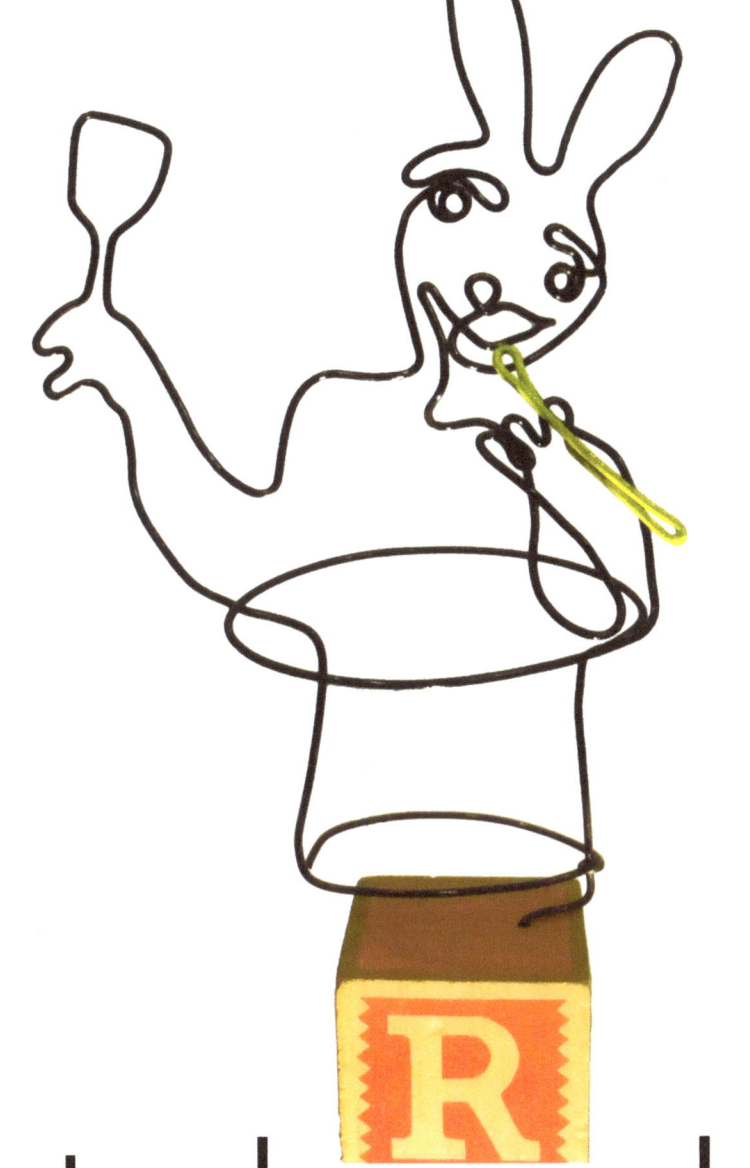

R is for Rabbit that steals your best hay

S is for Snail

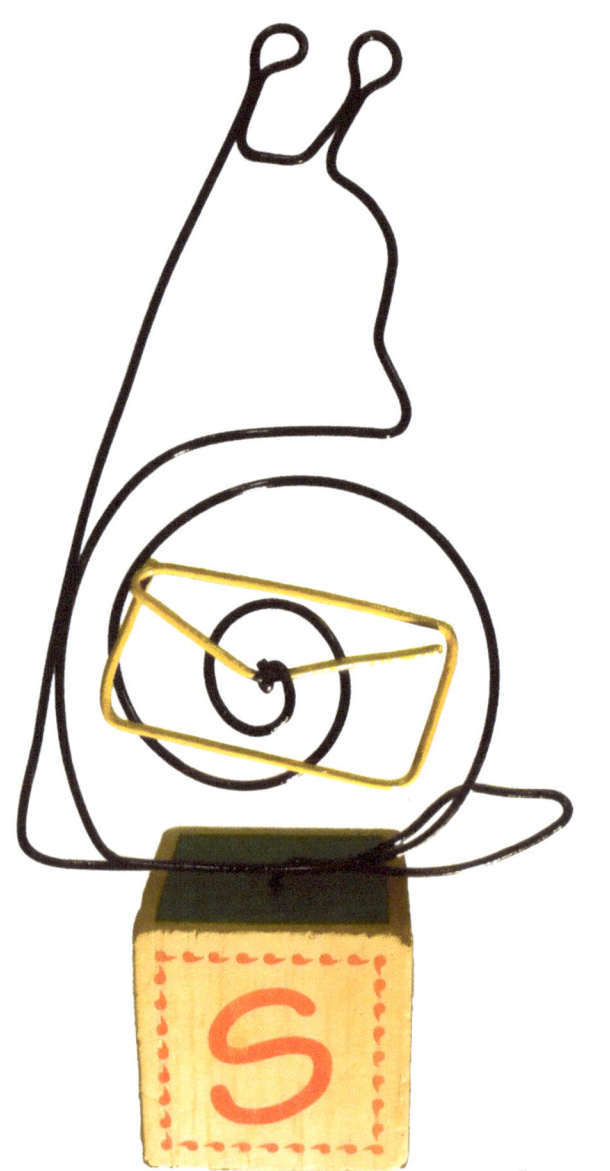

that moves mail so slow

T is for Teeth

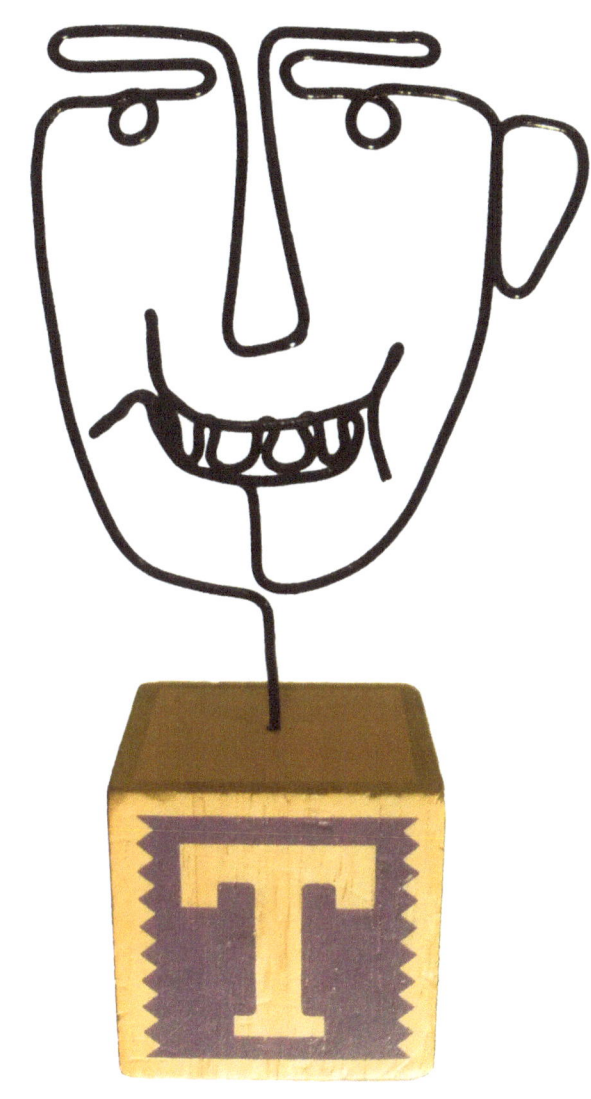

so bright that they glow

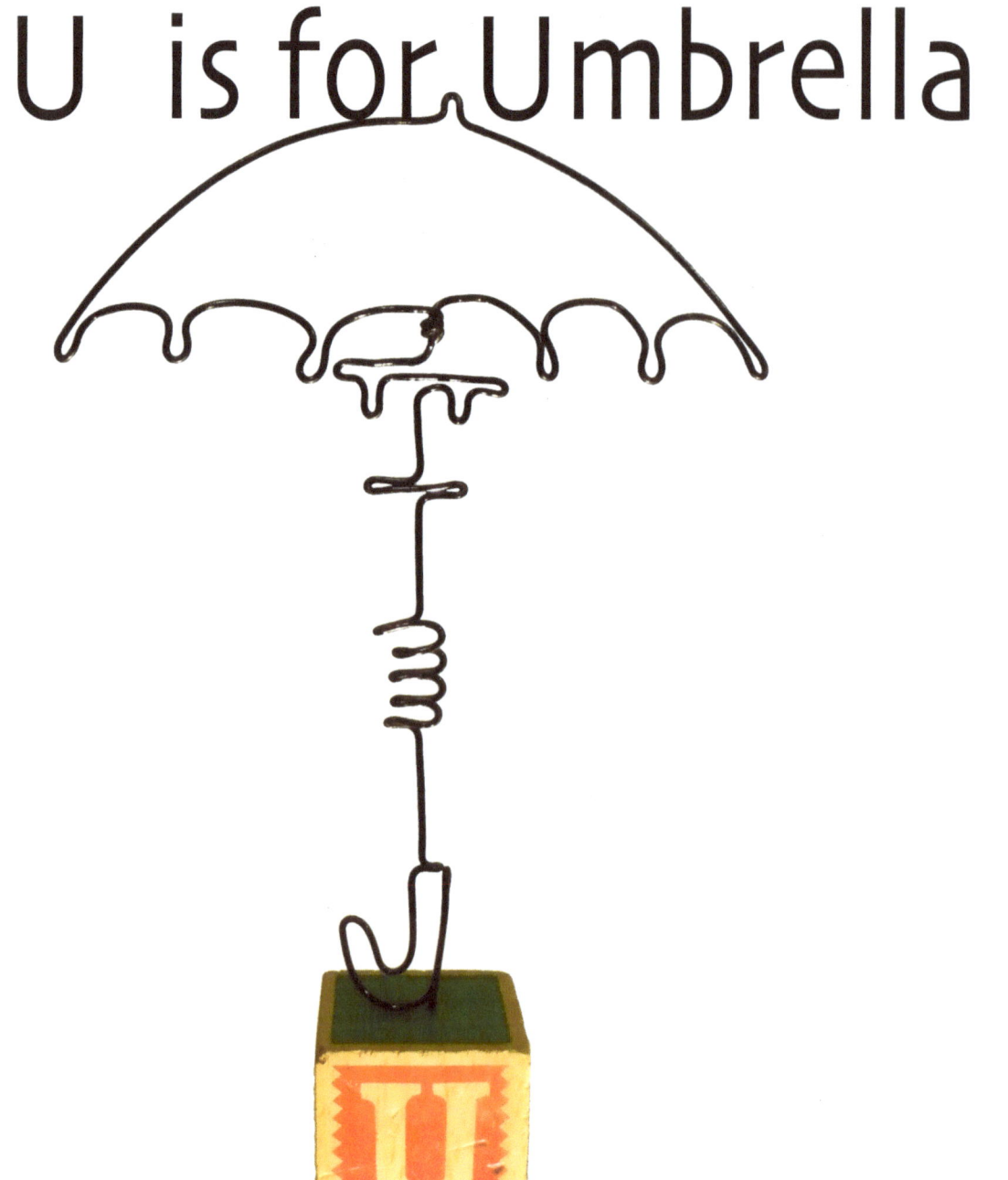

V is for Violin

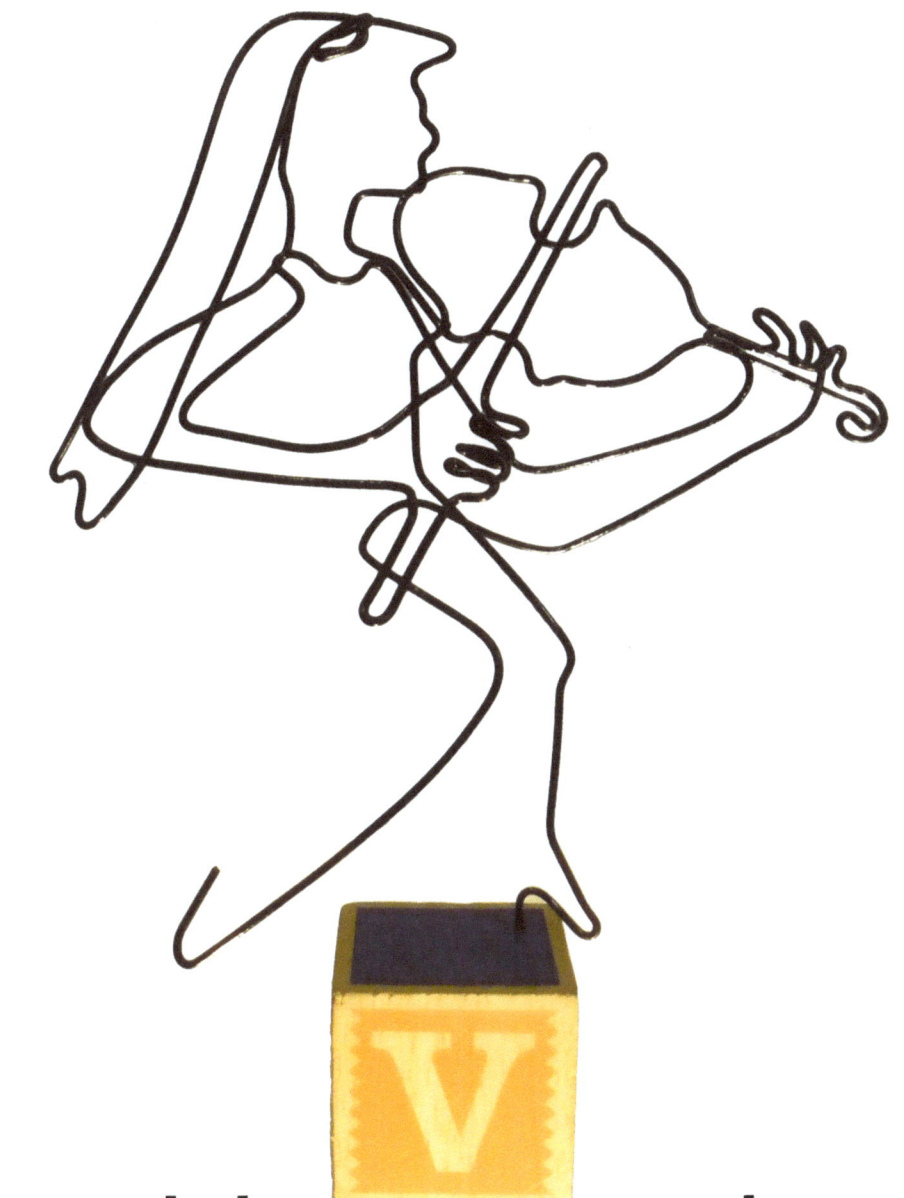

that tickles your brain

W is for Whale

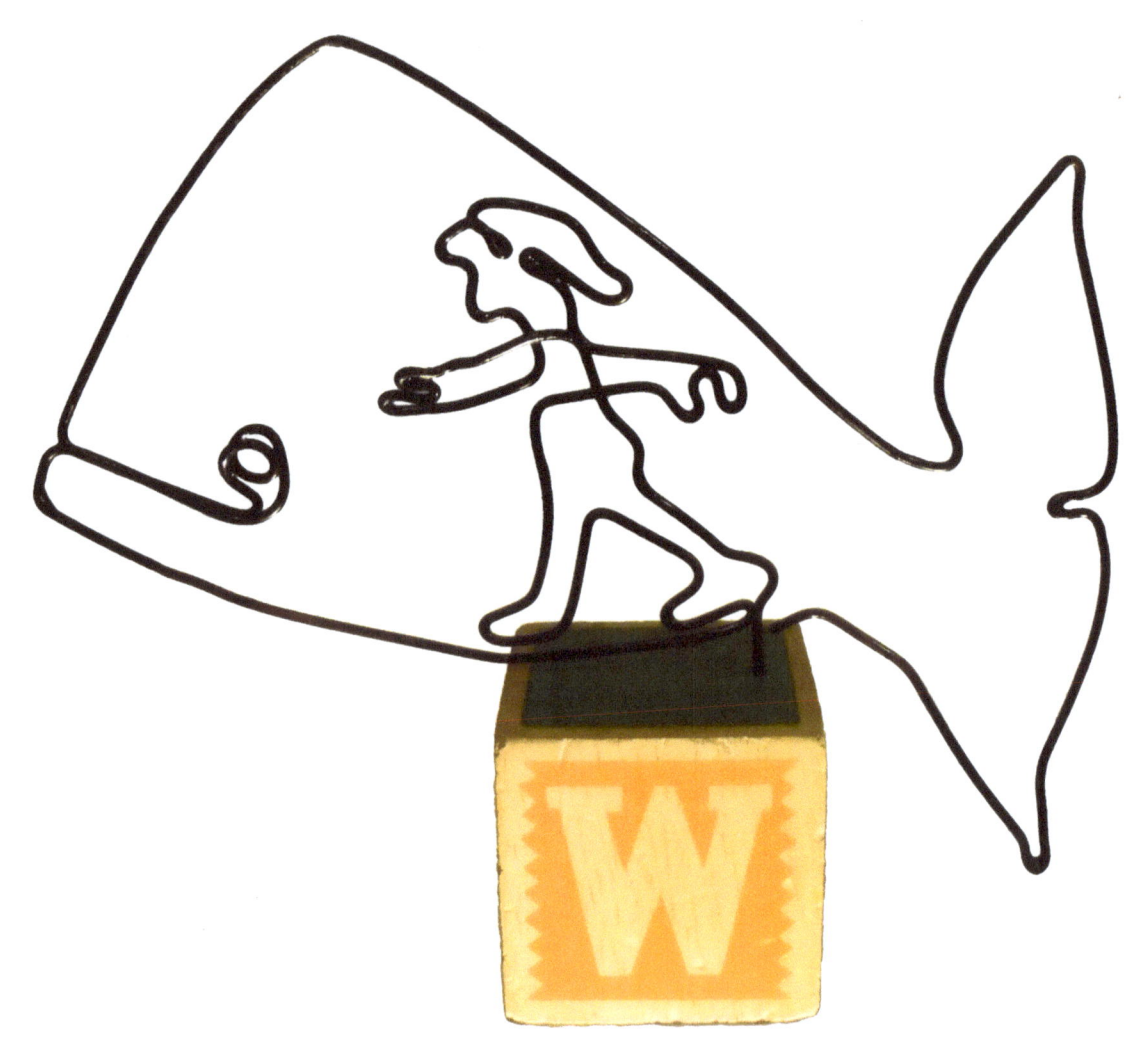

in which Jonah did pace

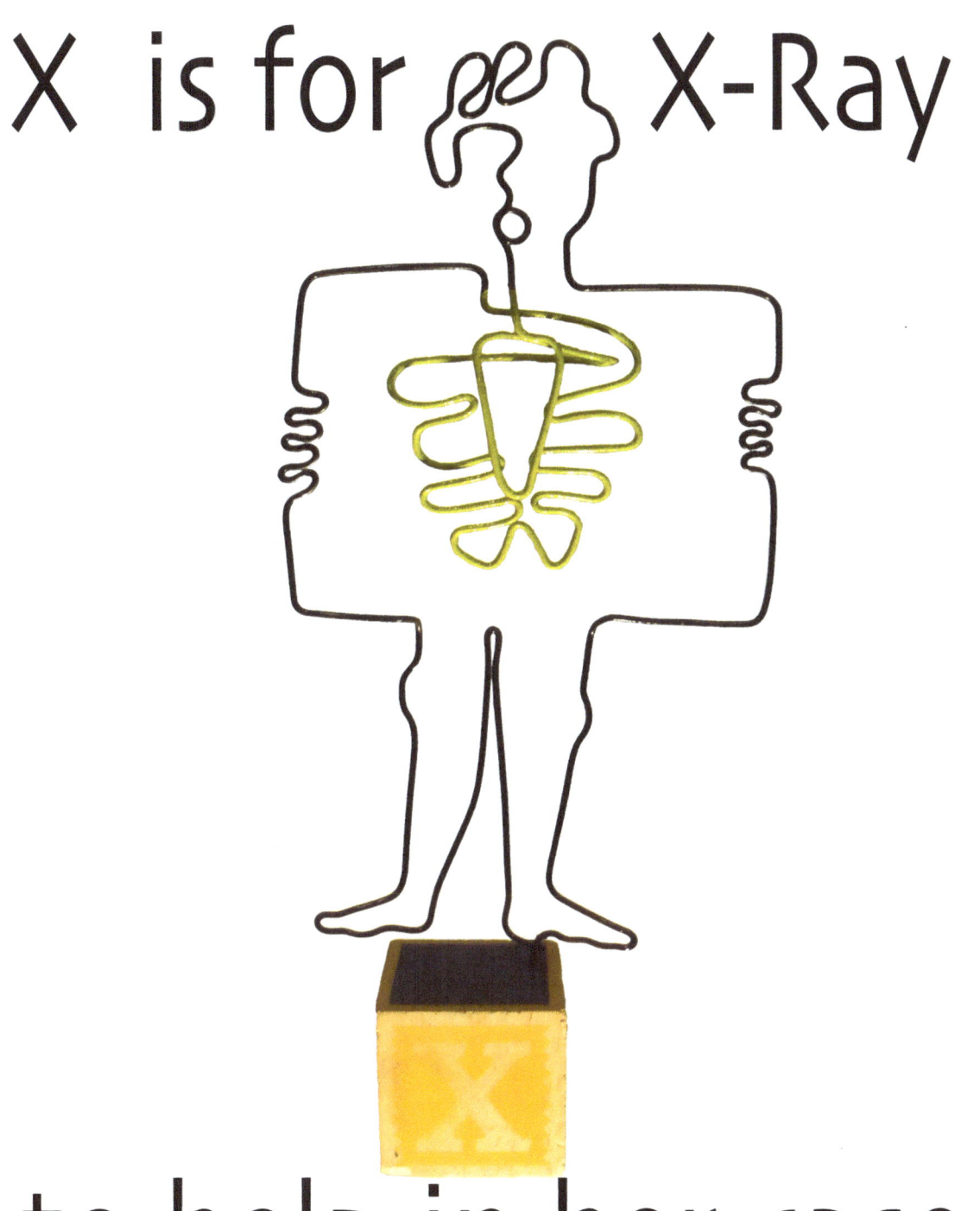

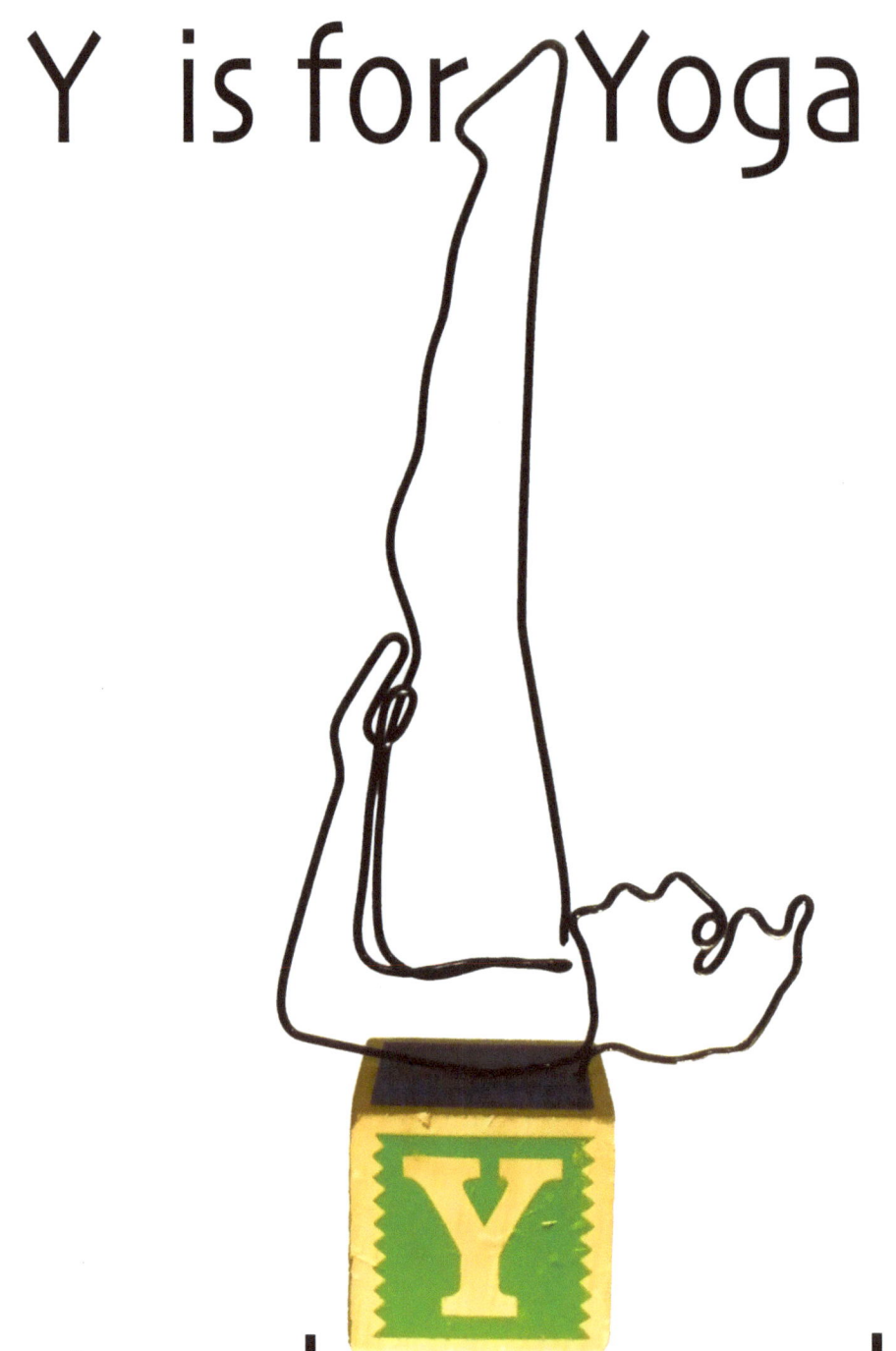

Z is for Zebra

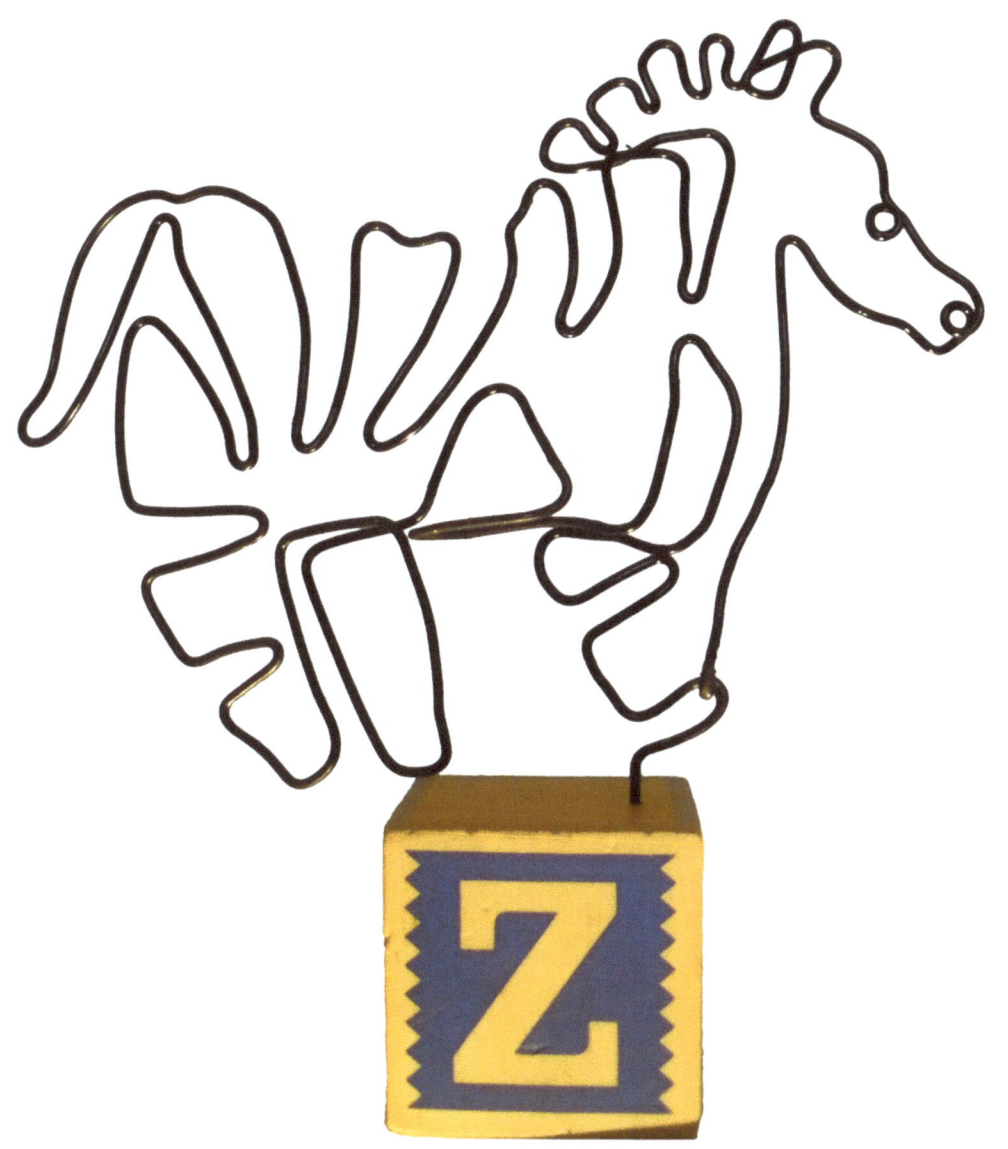

black and white but not read

www.ingramcontent.com/pod-product-compliance
Lightning Source LLC
Chambersburg PA
CBHW050403180526
45159CB00005B/2128